IMAGES
of America
SHASTA LAKE
BOOMTOWNS AND THE
BUILDING OF SHASTA DAM

America's second largest dam, Shasta Dam, stands 602 feet tall and is the keystone of the Central Valley Project. Water from this reservoir, over 4.5 million acre-feet, irrigates many northern California farms and provides drinking water for numerous communities. Shasta Dam's turbines can crank out a total of 625,000 kilowatts; much of this electricity is used to power industrial plants and thousands of California homes. In addition, Shasta Dam helps to even out the flow of the Sacramento River, making it navigable as well as protecting the Bay Area delta region from the intrusion of salt water.

IMAGES of America
SHASTA LAKE
BOOMTOWNS AND THE BUILDING OF SHASTA DAM

Al Rocca

ARCADIA

Copyright © 2002 by Al Rocca.
ISBN 0-7385-2076-4

Published by Arcadia Publishing,
an imprint of Tempus Publishing, Inc.
3047 N. Lincoln Ave., Suite 410
Chicago, IL 60657

Printed in Great Britain.

Library of Congress Catalog Card Number: 2002110138

For all general information contact Arcadia Publishing at:
Telephone 843-853-2070
Fax 843-853-0044
E-Mail sales@arcadiapublishing.com

For customer service and orders:
Toll-Free 1-888-313-2665

Visit us on the internet at http://www.arcadiapublishing.com

The first bucket of concrete was placed at Shasta Dam on July 8, 1940. Workers and officials gather around the bucket for a ceremonial photograph. On the far right, with his hand on his knee, is Frank T. Crowe, considered by this time to be America's master dam builder.

Contents

Acknowledgments		7
1.	The Shasta Dam Project Begins, 1938	9
2.	The Shasta Dam Boomtowns, 1938–1945	27
3.	Shasta Dam Construction, 1939–1940	49
4.	Shasta Dam Construction, 1941–1942	67
5.	Shasta Dam Nears Completion, 1943–1945	89
6.	The Boomtowns and Shasta Dam After, 1945	115

ACKNOWLEDGMENTS

The research and preparation of the photos and captions for this book are the result of a collaborative effort between the Shasta Historical Society, Shasta Lake City Library, and the U.S. Bureau of Reclamation. The Shasta Historical Society supplied several of the Boomtown photos of Central Valley and Summit City.

Sheri Harral provided access to the thousands of Bureau of Reclamation photographs that are archived at the Shasta Dam Visitor's Center. Tami Corn spent hours laboriously scanning almost 200 photographs of outstanding quality that depict the entire construction sequence of Shasta Dam. She also found rare photographs of Shasta Dam Village and Toyon (government camp).

A very special note of thanks goes to Shasta Lake City historian-librarian, Hazel McKim. This is the second book in which the author has worked with Ms. McKim and she, once again, provided invaluable information about the people, places, and events surrounded with the building of Shasta Dam. It is with great pleasure that I dedicate this book to Hazel McKim.

—Al M. Rocca, July 2, 2002

Pictured, left to right, are: Sheri Harral, Public Affairs Specialist, U.S. Bureau of Reclamation; Hazel McKim, Shasta Lake City Historian-Librarian; Tami Corn, Reclamation Guide, U.S. Bureau of Reclamation; and Dr. Al M. Rocca, Professor of Education and History at Simpson College.

Note: All photographs in this book, unless otherwise noted, are courtesy of the U.S. Bureau of Reclamation. Photos on pages 120 through 128 are by the author.

One
THE SHASTA DAM PROJECT BEGINS, 1938

This photograph reveals the rugged terrain of the canyon area that engineers decided would be the best site to erect mighty Shasta Dam. This view is looking downstream as the Sacramento River winds its way through Shasta County. Upstream from this location sat the once thriving copper mining town of Kennett. Note the railroad tracks on the right bank of the river. The irregular flows of the Sacramento River, before the dam was erected, caused flooding in the winter that proved a constant problem to farmers and growers further down in the Sacramento Valley.

A prospector pans for gold in the Sacramento River below Pollock, California, May 1936. Pierson B. Reading, the first White settler in Shasta County, discovered gold in the southern part of the county shortly after James Marshall's famous discovery in 1848.

Just a short distance upstream from where Shasta Dam would be built was the town of Kennett. Once a prosperous copper mining community, Kennett became deserted once construction on the dam began. June 1936.

This photograph reveals a scene along the Sacramento River near the dam site showing denuding of the landscape as a result of the copper smelter fumes that killed off most of the vegetation. June 1936.

Not far downstream from the Shasta Dam building site sat a large copper smelter at Coram. This smelter produced large amounts of copper during the early years of the 20th century. June 1936.

A ceremony was held to mark the official naming of the project. Originally, the dam had been designated Kennett, but was changed to Shasta Dam at this event. Pictured, from left to right, are: Earl Lee Kelly, Director of California State Department of Public Works; Helene Mae Bacon Boggs, Shasta County pioneer; and John C. Page, Commissioner U.S. Bureau of Reclamation. September 12, 1937.

This is the Porter Seaman farmhouse on the government camp, later named Toyon. The Porter family property claim dated back to 1870. The home would be renovated by the Bureau of Reclamation and used as a community center. January 26, 1938.

Long rows of two room cottages are seen here being constructed on the east side of 2nd Street in the government camp of Toyon. This view is looking south from Holly Avenue. Construction of the government camp took place on the former Seaman farmstead. January 25, 1938.

The north section of Toyon is shown in this photograph, as seen from the west. Some three- and four-room homes were constructed in addition to the many two-room cottages. January 25, 1938.

This aerial photograph reveals the prospective site of construction for Shasta Dam. Cartographers drew in the extent of the dam across the canyon and the proposed Sacramento River diversion tunnel. The flow of the river is also shown.

Pictured is Ralph Lowry, construction engineer with the U.S. Bureau of Reclamation. Previous to his assignment as engineer in charge at Shasta Dam, Lowry supervised the government inspections of Hoover Dam. Lowry worked closely with contractor superintendent, Frank Crowe, to make sure that all construction phases of the operation were built to high engineering standards. June 10, 1938.

14

The main administration building is under construction at Toyon, June 11, 1938. First called Kennett camp, government officials and dam workers later christened the town Toyon, after the red berries in the area.

Many single men worked on Shasta Dam. Here at Toyon, the government built this large dormitory to help house the scores of Bureau inspectors and workers. June 11, 1938.

A typical duplex residence is shown here nearing completion in Toyon. June 11, 1938.

A railroad bypass tunnel was needed to reroute trains from the riverbed area. Later the tunnel would be used to funnel the Sacramento River around the work site. This photo of the downstream portal shows the very first timbering and drill rigs being placed to start the tunneling operation. August 12, 1938.

One of the first operations for Crowe and Lowry was to have road access to all parts of the work site. Here a bulldozer works to cut out a roadbed for the highway on the east abutment of the dam. September 21, 1938.

Early in the construction operation, Crowe ordered a temporary truck bridge to be built across Sacramento River. The bridge was just downstream from the dam site. This view is looking upstream. September 21, 1938.

Eventually hundreds and then thousands of workers labored on Shasta Dam. Here we see workmen leaving by truck at the end of a shift. September 23, 1938.

This photograph provides a general view of contractor's camp, also known as Shasta Dam Village, looking southwest. September 30, 1938.

Aware that heavy construction projects create situations where serious injuries can occur, officials built this hospital at contractor's camp. The 25-bed hospital contained an x-ray machine, was air-conditioned, and was thought to be, at the time, one of the best medical facilities north of Sacramento. October 28, 1938.

Pacific Constructors Incorporated (PCI) used this building as their main administrative center. Here Frank Crowe and his staff of assistant superintendents and foremen planned each step of the construction sequence over a period of five years. October 28, 1938.

How does one feed 2,000 men at one time? That became the main question for PCI officials once operations began full scale. The answer was to build this huge H-shaped mess hall. Workers could chow down three all-you-can-eat meals. October 28, 1938.

There was a long waiting list to get into the 172-man dormitory at Shasta Dam Village. Workers living here were close to the mess hall and large all-purpose recreation room, where they could shoot pool or play cards.

This photograph shows a carpentry crew working on family residences in what was to become Shasta Dam Village. As with the dormitory demand, workers found it difficult to acquire a room in one of these homes. Eventually, over 100 of these compact homes were built. October 26, 1938.

Shasta Dam Village spread out just a few hundred yards downstream from the dam site. This is a general view of the residential section looking downstream with the water tower in the foreground. By the time of this photo, 130 single family and duplex residents had been erected. December 15, 1938.

One of the first construction steps needed was to divert the Sacramento River along one side of the canyon so that excavation could begin. Workers are shown here during excavation operations in the river diversion channel along the left bank. November 27, 1938.

Large amounts of blasting were necessary to help with excavation. Here workers use a battery of wagon-mounted drills to help set the charges while working in excavation of the river diversion channel along the left bank. November 27, 1938.

This is a general view of excavation operations on left, or east, abutment as seen from a point on the right abutment, or from the west side. November 27, 1938.

Prior to actual construction, officials for PCI built this model of the Shasta Dam site. Crowe used this model to visualize the entire five-year construction plan. November 27, 1938.

Toyon Schoolhouse was built by Pacific Constructors Incorporated on government property near Toyon. Everyone was surprised to find on the first day of school how many students actually showed up, and the enrollments quickly swelled to even greater numbers in the following months. December 15, 1938.

The U.S. government's agency to help put young people to work during the Great Depression, the Civilian Conservation Corps (CCC), was put to work during the construction of Shasta Dam. This photo shows the mess hall at Baird CCC camp north of the dam site. December 22, 1938.

Members of the American Society of Civil Engineers accompanied by U.S. Bureau of Reclamation officials stop for an inspection tour of Shasta Dam. This photo was made at the contractor's mess hall.

Work is progressing in the railroad bypass tunnel as shown in this interior view of the tunnel. The timbering and steel rib support are set in preparation for concrete operations. January 25, 1939.

A telephoto view of work progress on the right abutment (west side) is seen in this photo. Blasting the mountainside occurred almost every day during the first few months of work. Despite strict safety codes and procedures, injuries did occur. March 23, 1939.

These high scalers are at work on the upper section of the right abutment excavation, chipping out loose rock with shovels. This dangerous job, made famous by the work done in cliffs at Hoover Dam, paid higher wages than most jobs. August 18, 1939.

Two
THE SHASTA DAM BOOMTOWNS, 1938–1945

This sign says it all. In response to the hundreds, later thousands, of incoming job seekers, business leaders from all over the northern California bought up land as near as they could to the actual construction site. Three major communities formed in addition to the already existing government camp of Toyon and the contractor's camp of Shasta Dam Village: Project City, Central Valley, and Summit City. Collectively they became known as "the Boomtowns." (Courtesy of Shasta Historical Society.)

All through the summer of 1938 homes such as the one pictured above sprouted up in all of the boomtowns. Usually small in size, these boomtown homes proved adequate for most migrants. In some cases, hired workers were able to bring home and use scrap lumber from the job site. (Courtesy of Hazel McKim)

Stores offering both new and used products quickly dotted the landscape in and around the boomtown area. Many families struggled financially as they waited for large scale hiring to begin on the dam. (Courtesy of Hazel McKim)

Part of Central Valley is visible here, looking west from an area near the railroad underpass. Note the Shasta Theater on the left and the Jolly Jones Union House on the right. Dancing and drinking establishments flourished as a means to entertain off-duty dam workers. (Courtesy of Hazel McKim)

This photo was taken from a point on the other side of the railroad underpass. Note the same Coca-Cola sign is clearly shown on the left side of the road. (Courtesy of Hazel McKim)

The Dam Shack was appropriately named, as it was not far from the construction site. Customers were treated to delicious meals and there was even some room for dancing. (Courtesy of Hazel McKim)

Volunteers pose in front of the Central Valley Fire Department. With the extremely dry conditions in the area during the scorching hot summers, firemen were kept busy all over the boomtown area. The original fire truck has been restored and is driven in parades. (Courtesy of Hazel McKim)

Eventually the Central Valley Fire Department purchased a second fire engine and built another station to house the equipment. Note the heavy snowfall, even though the boomtown area is only a few miles from Redding, where snowfall is much less. (Courtesy of Hazel McKim)

The need to expand the fire building was solved by raising the existing firehouse and simply adding a bottom story. Note the sign that states, "Masons labor donated by K.E. Stubblefield to C.V. fire department." (Courtesy of Hazel McKim)

Begun in 1939, the "Hell's Gulch" celebration was an attempt to raise money for local educational needs and for fire fighting equipment. Local entrepreneurs Clyde Akin, Lee Griner, and Earl Wiggins helped coordinate the community event. The burning of "'Old Man Gloom" is a reference to the dark Depression days of previous years. (Courtesy of Hazel McKim)

The "Hell's Gulch Bank" gave out "Dam Money" and "Boomtown Bucks." Known as "strictly funny money," the currency could be used by celebration attendees to trade for a variety of goods. (Courtesy of Hazel McKim)

Of the three boomtowns, Central Valley quickly established itself as the largest and most prosperous community. A full line of services from an official post office to dozens of markets and dry goods stores lined Shasta Dam Boulevard. (Hazel McKim)

The teaching staff of Toyon School is seen here in the school's early years. On the left is the principal, Matt Rumboltz, who also taught students. Some of the classrooms had to fit 60 to 70 students until expanded facilities could be constructed. (Hazel McKim)

Polin's Little Reno was a favorite with many dam workers. As the sign says, customers played cards and shot pool during some of their off-duty time. (Hazel McKim)

The Red and White Store was one of the first to come into the area. Note the dirt parking area in front of the store. The government later paved Shasta Dam Boulevard after local residents continually complained of the increasing dust problem. (Courtesy of Hazel McKim)

This is one of two "Gateways to Shasta Dam." Notice the sign indicating that the federal reservation area is a "dry" (i.e. non-alcoholic) zone. (Courtesy of Hazel McKim)

Archie's Shasta Dam Market offered a wide choice of grocery items and was well-shopped by local families. Despite its reputation as a boomtown area, prices for most grocery and dry goods items remained stable. (Courtesy of Hazel McKim)

At its height during World War II, the boomtowns supported two local theaters, the Shasta and Mecca Theaters. Dam workers and their families frequented the Shasta Theater all year round. The air conditioning was very popular in the hot summers. (Courtesy Hazel McKim)

The Shasta Shopping Center and Hotel was located on Shasta Dam Boulevard near Toyon. Dam workers heading for home from their work would stop here to shop. Newly arrived job seekers checked in at the hotel, while they became acquainted with the area. (Courtesy of Hazel McKim)

The Silver Dollar Club, another of the very first boomtown businesses, served beer and "eats." (Courtesy of Hazel McKim)

As can be seen from this interior photograph of the Silver Dollar Club, both men and women enjoyed the friendly atmosphere and mixed drinks. (Courtesy of Hazel McKim)

This postcard was typical of many that dam workers would send home to awaiting families. (Courtesy of Hazel McKim)

Another interior of the Silver Dollar Club showing the provocative painting hanging over the bar and a pool table. The Silver Dollar Club lives on today and continues to enjoy wide popularity. (Courtesy of Hazel McKim)

Speculation in property ran wild during the summer of 1938 and after that time. For as little as $95 one could purchase a building lot. Terms could be arranged for $5 down and $5 a month. (Courtesy of Hazel McKim/ Les Pancake).

The Mint Pool Hall was located close to the Silver Dollar Club and it too thrived in the growing commercial boom. (Courtesy of Hazel McKim)

Wimpy's Hamburgers cooked large, delicious hamburgers for young and old alike. From the beginning of their opening, the owners, shown here, worked hard to expand their business and their service. The simple facade fronts were the least expensive way to build and advertise at the same time. (Courtesy of Hazel McKim)

Closer to the dam site than Central Valley was the community of Summit City. Here you see part of the new business center after the road was paved. All of the boomtowns sported their businesses along the main highway, with residences sitting directly behind. (Courtesy of Hazel McKim)

Two very popular business establishments in Summit City were the Summit City Market and Gateway Lunch House. The view here is looking west, with the Shasta Dam construction site just over the hill in the background. (Courtesy of Hazel McKim)

Another view of growing Summit City is shown in this photograph. The town was located near the corner of Shasta Dam Boulevard and the Kennett-Buckeye Road, with most of the business development on the latter. (Courtesy of Hazel McKim)

41

One of the boomtowns' most enthusiastic pioneers was Jonathan Tibbitts. He had a real estate shop in the area and actively helped bring water to the area. Here he is shown at one of the Hell's Gulch celebrations. Note the mask on one of the panel members. (Courtesy of Hazel McKim)

As noted before, most of the dam workers lived in small, yet comfortable homes. With housing a premium before the war years, many of these homes were in big demand. Today, a large number of homes in the immediate vicinity of the boomtown area are still occupied. (Courtesy of Hazel McKim)

This photograph reveals some of the earliest construction in Summit City. The road has just been graded and the buildings are beginning to go up. Some men, waiting to be hired on the dam, worked for local construction companies putting up these buildings. (Courtesy of the Shasta Historical Society)

The residents of Summit City were quite pleased after the government paved the main road leading into their community. Newcomers to the area found that it was difficult to obtain enough water for residences and businesses. Later residents discovered that underground access to water varied from one location to another. (Courtesy of the Shasta Historical Society)

The Flying "A" Associated gas station provided old-fashioned full service to motorists. During World War II gas would be rationed, yet since Shasta Dam was designated an AA-Defense Project, workers received extra gas. (Courtesy of the Shasta Historical Society)

The Public Market fire was a terrible disaster for boomtown residents, who had come to rely on the mercantile store for many household goods and groceries. As can be seen, the ruins show nothing standing, except an optimistic sign that stated the store would open on Wednesday! (Courtesy of the Shasta Historical Society)

Kids and adults loved the Shanty Shop with their giant milk shakes and super large hot dogs. Note the hand-painted price of hot dogs, 10¢, under the window to the left. (Courtesy of the Shasta Historical Society)

Compare this photograph with the earlier one showing the Wimpy's eatery by itself. Now note the further development, including a smoke shop and the Silver Dollar Club to the extreme left.

More businesses in Central Valley can be seen in this photograph. The Shasta Café and the Texaco gas station are shown in the foreground to the right, while the Central Valley Grocery store is behind. (Courtesy of the Shasta Historical Society)

Shasta Dam Boulevard became overcrowded with businesses and people. To the right in this photograph is the Standard Oil gas station and in the center is the famous Big Dipper Ice Cream Factory. The owners' award-winning recipe guaranteed lots of ongoing customers. Kids in the summertime would save their pennies to buy just one scoop of the delicious ice cream. (Courtesy of the Shasta Historical Society)

The Shasta Dam Associated service station served drivers in the Midway and Project City area, near Highway 99. This station also served lunch. (Courtesy of the Shasta Historical Society)

Cold beer was in high demand year round and delivery trucks were constantly making their rounds of the boomtown saloons and eateries. This photograph was taken from Shasta Dam Boulevard looking to the northeast. (Courtesy of the Shasta Historical Society)

Three
SHASTA DAM CONSTRUCTION, 1939–1940

Shown at the right abutment inspecting construction operations are, from left to right, Frank T. Crowe, superintendent of construction for Pacific Constructors Inc.; Frank Bryant, superintendent of excavation for the contractor; Roland Curran, secretary-manager of the Central Valley Project Association; and Walker Young, supervising engineer Central Valley Project. May 13, 1939.

One of the most dangerous jobs working at Shasta Dam involved working in the blasting operations. Here two workers prepare dynamite for loading blast holes at the right abutment. April 18, 1939.

Bureau inspectors used this vehicle to check out various finds of aggregate. This mobile aggregate testing unit, shown here in front of the administrative building at Toyon, helped guarantee overall aggregate quality. May 18, 1939.

A view of the government camp at Toyon is shown here. The photograph was taken from a nearby hill. Government planners tried to save as many trees as possible while laying out the community. April 27, 1939.

CCC enrollees are shown here felling a large oak tree in clearing operations along the McCloud River. The two workers are working the crosscut saw while a third man drives the wedge.

The railroad bypass tunnel is shown here looking downstream from the plug section showing the joint between rock and concrete sections at the end of the plug. Much of the 1,800-foot long tunnel has already been concreted.

The first Southern Pacific railroad train to pass through the bypass tunnel at 3:00 p.m., June 26, 1939 was the northbound fast freight train. This view shows the train emerging from the north portal of the tunnel.

52

Ralph Lowry, construction engineer in charge at Shasta Dam, worked out of this administration building at Toyon. Here we see the recently completed building. Labor for completing the community landscaping was provided by CCC workers. June 7, 1939.

The two government-built dormitories dominated the landscape at Toyon. Workers paid a small monthly fee to receive a room in the dormitory. It was air-cooled and comfortable most of the year.

CCC workers completed the attractive landscaping in the residential section of the camp. Strict regulations forbade residents from changing the landscaping or adding rooms on to their homes. June 7, 1939.

Flood water levels from the Sacramento River reached an all-time record stage in early 1940. This panoramic view is from the end of cableway runway B looking down upon the contractor's railroad bridge and the river towards Coram. The flow of the river was estimated at more than 185,000 cubic feet per second. February 28, 1940.

The right abutment operations are seen here in a photo taken from the left abutment roadway. The powerhouse, penstock grates, abutment excavation, and cableway headtower can be seen. Tail towers on downstream can be seen in the foreground below. March 19, 1940.

This inspector is checking one of the many training pulleys of the conveyor belt that maintains the alignment of the belt. These pulleys were spaced about every 100 feet throughout the conveyor system. March 27, 1940.

The aggregate conveyor system ran from the Kutras Tract on the Sacramento River in Redding, 10 miles north to the Coram receiving station. From there another conveyor belt delivered the rock and gravel to the concrete mixing plant. March 27, 1940.

In this general view of the left abutment, we can see the excavation and the river channel as seen from the hoist deck in the 456-foot cableway headtower. This deck is approximately on crest level elevation of the dam. April 1, 1940.

The 460-foot cableway headtower and concrete mixing plant is seen from an area near the riverbed. Eventually, workers installed seven cables that stretched over 1,000 feet across the canyon to tail towers on the opposite abutment. April 23, 1940.

On a regular basis, hydraulic crews washed down loose fragments of rock from excavated areas to permit detail examination of the foundation. April 23, 1940.

Another dangerous job, a job that required constant attention to your work, was that of jackhammering. This jackhammer man is working over a small ledge in the downstream side of the right abutment excavation. April 23, 1940.

Visiting politicians and foreign dignitaries, interested in the progress being made on the mighty dam toured the work site every month. Here we see Gov. Culbert L. Olson of California posing for this photograph at the left abutment observation point. May 3, 1940.

Cableway #1 reaches the headtower and riggers are shown here on the top. They are connecting the 3-inch braided cable to the tower travelers. The cable weighed 22 pounds per linear foot. May 8, 1940.

A critical point in the construction involved stringing the 3-inch diameter cables to the headtower and tail towers. This view shows cableway #1 being strung from the left abutment to the headtower. May 8, 1940.

Here we see the delivery of the concrete aggregates on flight #23 of the conveyor belt. The belt is carrying 3-inch to 6-inch cobbles from a Sacramento River site to the Coram sorting site, approximately 10 miles north of Redding. May 9, 1940.

To keep the concrete operations going 24 hours a day, 7 days a week, workers kept a large reserve supply of aggregate available. In that way, concrete mixing and placing could continue despite occasional breakdowns of the conveyor belt. Here the shuttle conveyor is loading gravel from the Coram site to the mixing plant at the dam site. May 13, 1940.

This is the first skip to go out over the canyon. On board for the maiden voyage are Bureau and PCI officials. May 14, 1940.

Cement handling facilities are being placed in operation. Here are shown the first 10 carloads of cement for Shasta Dam being unloaded at storage silos. Over 6 million barrels of cement went into the concrete mixing to build Shasta Dam. Much of this cement came from Henry Kaiser's cement plant near San Jose, California. May 20, 1940.

Here is a general view of the covered aggregate conveyor system and cement stockpiles as seen from road above looking obliquely downstream. Looking in the background, you can see where the conveyor belt crosses the Sacramento River. Columbia Construction Company's conveyor belt was the world's longest. It operated for five years and was later sold to a South African business firm. May 15, 1940.

This is a dragline operation at the Redding aggregate plant. These machines scooped thousands of cubic yards of rock to keep the aggregate sorting going around-the-clock. May 16, 1940.

61

The conveyor belt carried up to 9-inch cobbles to the Coram sorting operation and storage bins. June 11, 1940.

The first bucket of concrete for the dam proper is lowered into Block 38-B. The dam was built in 50-foot square block forms arranged in a complicated checkerboard pattern. A total of 6,541,000 cubic yards of concrete went into the building of Shasta Dam. To make this much concrete it took 11,975,000 tons of aggregate and 6,757,500 barrels of cement. July 8, 1940.

Officials for the Bureau, PCI and the state water officials pose for a picture in front of the bucket carrying the first load of concrete into the dam forms. Frank T. Crowe, America's master dam builder, is shown on far right. Ralph Lowry, Bureau engineer in charge, is directly across from Crowe, first person on the lower left. July 8, 1940.

This is a general view of concrete operations in Blocks #36 and #38. Once in operation, more cables were placed online and more and more men were hired. July 26, 1940.

In this photograph the diversion channel is clearly seen accepting some of the Sacramento River. On the right are the first few concrete blocks. The diversion channel inlet is in the background. Rising up over the blocks is a concrete bucket. August 14, 1940.

Bulldozers shove the last boulders into the river shutting off water flow into the old riverbed and funneling water into the diversion channel. The small earthen dam is called a cofferdam.

Keeping access open to both sides of the river was very important and this bridge across the diversion channel kept men on schedule. The dewatering of the main riverbed is in progress. August 17, 1940.

The foundation for the power plant is being laid in this photograph. Workers needed to put hundreds of yards of thick, reinforcing steel into every concrete block. Contrary to popular legend, no workers were buried in concrete in Shasta Dam. Each bucket covered only a small area of the 50-foot square form. August 27, 1940.

This is a Southern Pacific railroad wreck near the south portal of the railroad bypass tunnel. Note the mud and rocks that have washed down onto the rails, causing the derailment. October 24, 1940.

The massive headtower dominates the dam site. With seven cableways in action, concrete placement progressed rapidly in 1940. For a size comparison, note the men standing on top of the concrete forms. December 6, 1940.

Four
SHASTA DAM CONSTRUCTION, 1941–1942

The Goodyear blimp *Resolute* paid a visit to the dam site in early 1941. The crew shot film of the concrete placing and used it later in a public education movie. While not receiving as much national attention as Hoover Dam, progress in the construction of Shasta Dam was reported in many of the top newspapers and magazines. January 1941.

The contractor's layout board depicted the current blocks in which concrete was to be placed. Foremen, as shown here, studied the board before each shift. Frank Crowe, as superintendent of construction, made the final decision of the sequence of blocks to be worked. However, Bureau engineer Lowry had the power to stop any phase of the job if he felt blueprint specifications were not followed properly. February 4, 1941.

Inside a massive concrete dam it is necessary to construct extensive inspection galleries or tunnels. Here a worker is checking the reinforcing bars installed around a gallery in Block #31-D. March 4, 1941.

An excellent water-level view of the left abutment concrete operation is seen here in this photo. The inspection galleries are clearly seen at several levels. March 4, 1941.

An 8-cubic yard of freshly mixed concrete is placed in Block #48-E. Frank Crowe designed the bucket during his many years of building dams in the West. Crowe pioneered the use of cableways in dam building as early as 1912 on Arrowrock Dam. March 6, 1941.

A form raiser removes she-bolts in preparation of raising the form for another round of concrete placing. Men worked an exhausting full eight-hour shift, made more difficult during the extremely hot summers in Shasta County. March 6, 1941.

Visitors watching construction from the Vista House came from all over the world. On any given weekend, curious local residents would bring out-of-town guests and relatives to the dam site to watch the big machinery in operation. Engineers, wanting to check on the effectiveness of the huge headtower, were drawn to the dam site as concrete operations started. March 13, 1941.

A national radio broadcast from the contractor's administration building followed this meeting of Frank Crowe and visiting journalists. Pictured left to right are Arthur Van Horn, A.W. Scott, Frank Crowe, Mel Venter, and John Hughes.

Necessity is the mother of invention and in the case of dam building; engineers are always looking for more efficient ways to do the work. Here we see a detailed view of pneumatic tamper converted from a jackhammer and used as a tool to tamp backfill. April 8, 1941.

The first millionth yard of concrete was placed on May 3, 1941.

Public recognition was paid to these three men for saving the life of B.S. Hodges on October 20, 1940. The men are, from left to right, George Baze, Mark Whitaker, and N.A. Takala. It was the quick thinking Takala who provided artificial respiration that revived Hodges. May 10, 1941.

Swarms of drillers are seen here working an area that needed further excavation. Foremen watched carefully for lazy workers or any that did not follow safely rules. Safety was a major issue on Shasta Dam and it was the responsibility of the foremen to report any and all incidents. May 19, 1941.

Jackhammer men drilling blasting holes in the upstream face of the excavation needed to be careful every second of the operation. This must have been exhausting work for even the strongest of men. In the center of the photograph is a very young worker attempting to handle the heavy jackhammer. May 12, 1941.

This photograph was taken from atop the 460-foot tall headtower. The left and right abutments are well on the way to completion as workers continued to labor in three shifts. Notice how much of the dam is actually dug into the side of the canyon walls. The foundation is well anchored into secure bedrock. Workers threw temporary planks down to step across from one block to another and they are clearly seen above.

Workmen coming off the day shift leave the dam via the staircase. Workers were required to wear safety helmets, gloves, and heavy-duty shoes or boots. May 23, 1941.

Tour guides were available to explain the general sequence of construction to visiting guests. Inside the Vista House visitors could see a model of the dam and how it would work, as well as a large model of the Central Valley Project. June 1, 1941.

Frank Crowe, superintendent of construction for PCI, posed for this photograph on June 20, 1941. Crowe joined the fledgling U.S. Reclamation Service in 1905 and built a total of 19 dams, with Shasta Dam his last. He died shortly after the completion of Shasta Dam, yet his pioneering techniques and methods for constructing large concrete dams remained standard practice for many years.

Engineers from the Bureau of Reclamation made regular visits to the dam site. Their job was to work with Crowe and Lowry as outside consultants to give advice on tricky construction problems. Pictured, left to right, are: J.L. Savage, visiting Bureau design engineer; Frank Crowe, superintendent of construction; S.O. Harper, visiting Bureau engineer; and Ralph Lowry, Bureau engineer in charge at Shasta Dam. August 12, 1941.

The penstock fabrication plant built sections of the 15-foot diameter penstocks that would, when installed, deliver water to the five turbines in the power plant. Note the comparative size of the panel truck. July 9, 1941.

Work did not stop when night came. Instead, Crowe initiated three full work shifts with almost no slow down in the work operations. Gigantic, high luminous lights flooded the canyon to allow workers to continue most jobs. Newly hired men usually started the graveyard shift and gradually moved into the swing or daytime shift. July 29, 1941.

Technicians used an x-ray machine to check the welds in every penstock that was constructed. It was vital to find cracks immediately after the weld fabrication process, as once they were installed, the penstock water pressure would be tremendous. Incredibly, the sections nearest the powerhouse were made considerably thicker than the sections where the water entered to handle the increased water pressure. August 27, 1941.

First time visitors to the dam site gasped when initially glimpsing the awesome size of the 460-foot headtower. Frank Crowe and his engineering nephew, John Crowe, conceived of the idea using a single large headtower while they were finishing up work on Parker Dam on the Colorado River. Crowe had used the cableway system many times before, but never spanning such great distances. August 13, 1941.

Men are shown here being transferred to the dam site from the dormitory and recreation hall area. As the various crews worked together, friendships formed that lasted for decades after the completion of the dam in 1945. In fact, ex-dam workers continue to hold annual reunions in Shasta Lake City.

Sgt. H.E. Whitlatck, U.S. Army, guards the diversion tunnel the day after the Japanese attack on Pearl Harbor. Everyone working on the dam was devastated by the news of America's entry into the war, and men debated whether to remain on the job at Shasta Dam or join the service. December 8, 1941.

Conveyor belt operation was interesting to watch. Consisting of 26 flights, of which the longest was two-thirds of a mile, the conveyor belt could deliver up to 1,000 tons of aggregate an hour. Each flight was powered by a 200-horsepower motor that was recharged by generators on the downhill slope of each flight. All flights of the conveyor belt were remotely controlled from the Coram receiving end, near the dam.

This view of the right abutment, downstream face of the dam shows progress in placing the penstocks.

With war hysteria at a height in March of 1942, extra guards, such as this corporal, were ordered to guard key construction areas. Here he is standing near the diversion tunnel. March 5, 1942.

Workers unloading cement are seen here resting during their lunch hour. More and more men quit their work at Shasta Dam and enlisted to fight in the Pacific and European theaters of war. Some of them relocated to the San Francisco Bay Area, particularly to the new Kaiser shipyards in Richmond and Alameda, for higher paying positions. March 5, 1942.

Boomtown residents thrived on social interactions and many of those gatherings were here at the Toyon Community House. March 14, 1942.

This photo provides a general view of the left abutment as seen from the right abutment showing gallery chambers. The galleries were set out at regular heights within the dam. Bureau inspectors checked the interior condition of the dam, including monitoring concrete drying temperatures and searching for cracks or movement.

Parents tried to carry on a normal social life for their children despite the all-encompassing pressure to build the dam and win the war. Food and gas were rationed, as well as many other items later in the war. Here some local children are seen playing at the Toyon Community House during a recent snowstorm.

The third-millionth cubic yard of concrete was placed on March 28, 1942.

The buildup of latent heat in drying concrete can result in major structural failure unless the heat is dissipated soon after placement. At first, water from the Sacramento River was passed through copper cooling pipes that interlaced every concrete block. Even more effective was the use of refrigerated water that flowed through the cooling pipes at a cold 35 degrees Fahrenheit.

A worker waves to his fellow dam workers below from the top of the cableway headtower. A highly trained crew of men ran the cableway controls and communicated with concrete-placing foremen below through the use of telephones and hand signals. Pinpoint accuracy was needed on every placement and this became even more critical as the dam rose and the pressure to finish construction increased. March 25, 1942.

This photograph reveals the extent of progress over the entire dam site. This view is from downstream looking upstream. Notice the conveyor belt, on the left side, climbing the hill to the concrete mixing plant. May 13, 1942.

The homes in Toyon were built to high construction standards and provided full services. These homes, owned by the federal government, provided residents with a comfortable living environment, including the option to build backyard brick grills. Within certain limits, the Bureau allowed home renters to garden and landscape their backyards. June 9, 1942.

As dam construction continued on schedule, Bureau officials, including Ralph Lowry, pondered what to do with the remains of the old copper mining town of Kennett. Here we see the old post office in Kennett. During its heyday in the early 20th century, Kennett was home to hundreds of copper miners and their families.

A major landmark of the old Kennett community was the two-story schoolhouse. June 12, 1942.

Children pose together in front of the Toyon Community Center. The Bureau of Reclamation rebuilt the old Seaman ranch house and put in a large lawn.

The Shasta Dam power plant is shown here under construction. Notice the temporary wood and concrete barrier that is keeping water funneled away from the plant.

The tail towers played an important role in concrete placing operations. This photograph was taken by a Bureau photographer at the base of one of the seven tail towers. Sitting on tracks, the tail towers could be moved laterally to cover every area that needed concrete placement. An ingenious design, the cableway system worked almost flawlessly for over four years, ending in 1945. July 14, 1942.

This photograph was taken a mile or so upstream and it shows the dramatic rise of the dam in 1942. The Bureau of Reclamation received constant pressure from Congress to complete the dam so that hydroelectric power could be sent to the Bay Area, where industrial war plants were in desperate need of more electrical power. July 16, 1942.

From the dam site, a Bureau photographer grabbed this shot of Mount Shasta in the distance, looking north.

Five
Shasta Dam Nears Completion, 1943–1945

With World War II in full swing, work continued on Shasta Dam at a sustained pace. Crowe and Lowry, along with their staffs, constantly walked the dam site job sites to search for ways to increase the efficiency of work. By 1943, cableway operators had worked out any early problems with coordinating all seven cables. In this photograph we can see a tail tower on the west side of the river. Right behind the tail tower are the penstocks, reaching closer to the powerhouse. March 4, 1943.

With the railroad bypass tunnel completely lined with concrete, workers now dug a deep trench to funnel the diverted Sacramento River water around the riverbed. You can see the powerhouse to the right of the tunnel. The dam looms large in the background.

Progress on the upstream face of the dam is shown in this beautiful night photograph. The dam was built in rows and some of the rows were left low to allow for river water to flow through. This was necessary until the diversion tunnel was completed.

This photo shows the trashracks being constructed. Their purpose was to screen out large debris from entering the penstocks, which could damage the electric turbines in the powerhouse.

Crowe decided to leave Block #40 low so that he could use it as a diversion flow zone. Later, water would be diverted through the diversion tunnel allowing workers to complete the concreting of the low blocks. This picture was taken from the powerhouse balcony.

Looking through Block #40 as concrete operations are in full swing, one gets the feeling of the enormous height of the dam. At over 600 feet tall, men felt tiny as they labored to set the forms for concrete placement. Notice the man about to enter one of the lower inspection galleries. There are over five miles of galleries in the dam. May 19, 1943.

An aerial view of Block #40 from the headtower reveals the overall progress in completing the concreting operation. Construction of the trashracks is well under way on the upstream face of the dam. May 20, 1943.

The town of Kennett, with some of the remaining buildings, is shown in this photograph. The government ordered everyone out of the area so that these buildings could be demolished. Wood buildings were to be burned, while bulldozers moved in to knock over brick and stone structures. May 21, 1943.

The photograph provides another view of the old mining town of Kennett, taken just before government demolition began. In hindsight, it would have been a good idea to relocate the historic buildings to a site above the projected water line.

The Toyon Community Center remained active during the war years. Here in this photograph children are holding hands during a group activity. June 9, 1943.

A worker stands on the edge of the diversion channel, as the Sacramento River is diverted through the completed railroad bypass tunnel. At this point only one-third of the river flow is going through the tunnel. By this time, the railroad had to be fully diverted around the entire dam site by construction of the Pit River Bridge. June 23, 1943.

This photo shows workmen standing in the construction joint of a river outlet conduit, before it is installed. The river outlet conduits would help regulate the flow of water through the dam. Their placement at varying heights in the dam gave some degree of water temperature control in their releases to the Sacramento River. June 22, 1943.

A Bureau photographer, standing from a spot just upstream from the dam, snapped this shot of the mouth of the diversion tunnel. The tunnel is now accepting the full flow of the Sacramento River. September 9, 1943.

This interesting picture, taken from a point halfway up the downstream face of the dam, gives the viewer a sense of the size of the project. Note that the two abutments are completed, while the center section is still being concreted.

Down in the main riverbed, now totally dewatered, crews worked to begin concrete operations in the spillway section. High above them, the diversion tunnel safely funnels the always-dangerous Sacramento River around the work site. November 17, 1943.

The penstocks are nearing completion in this photograph, with workmen cleaning and painting the huge pipes. Notice the large U-shaped clamps that have the responsibility of holding the penstocks in place as rushing water crashes downward to the awaiting electrical turbines. November 18, 1943.

Pictured is Frank Crowe with Bureau of Reclamation engineers S.O. Harper and Ralph Lowry, inspecting the work progress on November 17, 1943. In the background, work continues on installing the remaining penstock sections.

In anticipation of generating massive amounts of electricity, work crews are busy erecting transmission line poles from the dam site to power stations further south. November 27, 1943.

Electrical engineers carefully place the #3 electric rotor in its housing unit on December 1, 1943. The power plant, when completed, was and remains one of the largest in California. Seventy tons of water per second is required to drive each of the five turbines at full-generator load.

The sixth-millionth cubic yard of concrete is placed on December 23, 1943.

The rising water of the Shasta Lake reservoir is shown encroaching into the town of Kennett. January 8, 1944.

The Gold Nugget Café in Kennett is about to go under water in this photograph taken in early 1944. By this time, residents had evacuated and taken anything worthwhile with them. Bureau of Reclamation security officers kept the general public out of the area, by patrolling on land and water.

An operator is pictured here at work at the PBX telephone switchboard in the powerhouse. January 13, 1944.

These flames are leaping from houses in Kennett as government officials burn all of the wooden buildings. They did not want the debris to remain a hazard in the new lake. January 17, 1944.

Lawrence Bannon was one of the last residents of Kennett. Bannon lived in a house boat, after his regular home was flooded. He commuted by water to work. January 31, 1944.

This picture depicts the platform at headtower base showing the conveyor belt and mixing plant at left. The circular track brought the freshly mixed concrete to a position where the cableway operators could lift the concrete buckets and deliver them to any location on the dam. February 9, 1944.

Majestic Mount Shasta looms in the distance in this 1944 photograph of Shasta Dam. To the right of center, one can get a good look at three of the tail towers holding the long cableways in place.

Conveyor belt showing spray bars kept dust to a minimum. Inspectors and maintenance men constantly monitored the belt by driving along its 10-mile length. Rumors persisted for years that some dam workers actually rode the conveyor belt at different points along the line, but the spray bars certainly would have made that difficult. There was a stiff penalty for non-authorized personnel attempting to get on, or near, the belt. March 14, 1944.

This house was photographed on the Pit River. It had floated down Squaw Creek from Copper City, miles above the dam site. March 18, 1944.

103

Water is quickly rising up the face of Shasta Dam as shown in this photograph of March 21, 1944. Interestingly, you might wonder how the headtower could continue to function with water all around its base. Look to the right of the headtower and you can see a temporary suspension bridge that allowed workers to walk "across the lake" to their assignments each day. Plans called for removing the top half of headtower when work was completed, the bottom half remained below the final water line.

Horse teams were employed to pull electric transmission lines into place. March 25, 1944.

Another panoramic view of the entire Shasta Dam project during July, 1944. Notice the tops of the hills about to be covered by the rising reservoir. Only the very center of the dam remains to be concreted.

Many dam workers traveled the 10 miles south to the big town of Redding. Here they found a wider variety of shopping and entertainment, such as the Cascade Theatre shown here in this photograph. Today, the Cascade Theater is being renovated after years of non-use. July 25, 1944.

A favorite drink for dam workers and their families was Coca-Cola. A regional bottling plant was established in Redding. July 25, 1944.

Not to be out done, Pepsi-Cola Incorporated opened a bottling company in Redding also. July 25, 1944.

This is one of the first sail boats on Shasta Lake. July 14, 1944.

An interior view of the Shasta power plant looking at Units #3–5 is shown in this photograph. Each turbine can produce 75,000 watts. The large crane in the foreground is used to lift turbine components for maintenance and replacement. November 25, 1944.

The last bucket of concrete celebration on December 22, 1944, signaled the close of major construction on Shasta Dam. Frank Crowe is standing immediately to the left of the sign. Foremen and other workers joined Crowe for this photograph.

Shasta Dam was designed to be a concrete overflow dam. To this end, three giant metallic drum gates needed installation. They can be seen at the top of the spillway. December 20, 1944.

Houses in Shasta Dam Village are shown here being taken away by private companies that purchased the well-built homes and transplanted them to Redding and Chico. May 21, 1944.

Elizabeth Hoffmann, one of the few young women employed in the power plant, posed for this photograph on November 2, 1945.

To celebrate the successful end of World War II and the completion of Shasta Dam, Redding residents once again raised a giant Christmas tree on Market Street. At 95 feet high, the tree was the first since 1941. December 7, 1945.

An aerial view of Shasta Dam is shown in this photo. February 8, 1946.

Finishing work on the roadway nears completion in this photograph taken on January 29, 1945. The headtower is still functioning at this time, delivering much of the concrete for the finishing work.

The power plant exterior is shown in this photograph taken on February 10, 1945. Water from the rising reservoir is shown here passing through one of the 6-foot diameter outlet tubes.

As Shasta Lake rose higher and higher, investors pooled their cash to buy acreage that would give them lakefront property. Dreaming of large profits, these resort owners brought in boats of all sizes and shapes. Here we see the Shasta Boat and Yacht Club. This photograph was taken from the old road at the Pit River Bridge. June 14, 1944.

This picture is of a sunset view of the Shasta Lake. It was taken from Highway 99 near the Pit River Bridge. Word spread around the state and much of the American West about the beautiful scenery and recreational opportunities, including fishing. June 14, 1946.

Six
THE BOOMTOWNS AND SHASTA DAM AFTER 1945

With the resulting boom in recreation and lots of jobs in the nearby lumber mills of Anderson, California, the boomtowns continued to grow. Here we see a photograph of the Project City Hotel and boat building facility taken on March 15, 1946.

The Project City business district thrived with new and continued business. The photograph was taken from First Street looking toward Highway 99. March 15, 1946.

This is a panoramic view of Central Valley taken on March 15, 1946. Many of the returning World War II veterans returned to the boomtown area and decided to set up permanent households. For ex-dam workers, who had worked so hard and long on dams in the West, they knew that Shasta Dam would probably be the last big concrete dam built in America, and they were right.

Of the three boomtowns, Summit City remained the least populated. The view in this photograph is looking northwest at the main business district. Shasta Dam lies behind the hill on the right. March 15, 1946.

Here is a typical small residence in Central Valley near Montana Avenue and Main Street. March 15, 1946.

Here is another photograph showing homes in the boomtown area. While jobs were available in the immediate post-war era, the boomtowns never regained their full vitality.

This is the *Joseph L. Green* sightseeing boat on Shasta Lake passing under the Pit River Bridge. Boating became very popular not only for local residents, but also for many residents in northern California and soon the lake became dotted with watercraft. June 25, 1946.

Mary Lou Granger, daughter of Roscoe Granger, a field engineer at Shasta Dam, enjoys an afternoon on a water bicycle. July 8, 1946.

H.C. Martines, information agent, delivering a short talk to visitors at the Vista House main exhibit area. August 11, 1946.

C.S. Downing, guide at the Vista House, is shown delivering a talk on the workings of the Central Valley Project using a model diorama. August 11, 1946.

This photograph shows Shasta Dam's main spillway section with gates operating. July 18, 1951.

The Big Dipper today is just as popular now as it was in the heyday of the boomtowns.

This is the Shasta Lake City Fire Department today.

The Lion's Club Veteran's Memorial and Fountain was the idea of Dean Brobst and several others. Brobst, the club's first president, designed the memorial and helped with its construction in 1971.

Hazel McKim, Shasta Lake City historian-librarian, is seen here standing in front of the Shasta Lake Gateway Library. The library has been open since the city incorporated in July of 1993.

This is a view looking west on Shasta Dam Boulevard taken from the corner of Montana Street.

The Shasta Lake Senior Center was built with all volunteer labor back in the 1980s, and serves many functions. Healthy meals are served to seniors on a regular basis, and the center is used for community meetings, bingo games, and other special events.

North Valley Bank represents some of the new businesses that are moving into Shasta Lake City. Since the town's incorporation in July of 1993, a renewed spirit of civic pride invigorates the area.

MacDonald's Restaurant is one of several recent additions to Shasta Lake City. It is located at the junction of Interstate 5 and Shasta Dam Boulevard. This exit brings thousands of tourists into the town annually.

This is a photograph of the Silver Dollar Club today. Much of the exterior of the building is the same as it was decades ago.

Central Valley High School, part of the Gateway Unified School District, serves the entire Shasta Lake City area, offering outstanding academic and extracurricular programs.

Toyon School today has an enrollment of about 350 students in grades kindergarten through fifth grade. The school today is part of the Gateway Unified School District. Gateway's motto is, "The district that specializes in your child."

Pictured is the Margaret V. Polf Park, formerly known as the Buckeye Regional Park. Polf came to the Shasta Lake area in 1945 and became involved in the Shasta Dam Area Public Utility District. The PUD board in 1985 honored her years of dedicated service as a PUD board member by naming the new park in her name.

The only remaining building in the former government camp of Toyon is this abandoned storage building. A locked gate prevents visitors from walking the now vacant streets. Toyon was one of the last communities built and maintained by the U.S. Bureau of Reclamation.

Looking down from the visitor's center at Shasta Dam, curious onlookers can see the tree-covered hill that once held scores of single-family homes that were part of the contractor's camp, or Shasta Dam Village. To the right, storage and maintenance buildings sit on the edge of the Sacramento River.

Deer are common visitors to the grassy picnic area adjacent to the entrance to Shasta Dam.

Sports for all ages are popular in Shasta Lake City, with baseball being one of the favorites. This well-maintained ballpark is named in honor of former longtime U.S. congressman, Harold "Bizz" Johnson.

This plaque honors the men and women who worked in the construction of Shasta Dam and it sits in a tiny park in what was once part of Summit City.

These views of the three Shastas—Shasta Dam, Shasta Lake, and Mount Shasta—never cease to awe visitors and locals alike. Thousands of visitors continue to come every year to this magnificent setting for boating, skiing, and camping. Shasta Lake City eagerly continues to grow in population and commercial activity, and it proudly serves as the "gateway to Shasta Dam."